D0852626

'60s Flashback

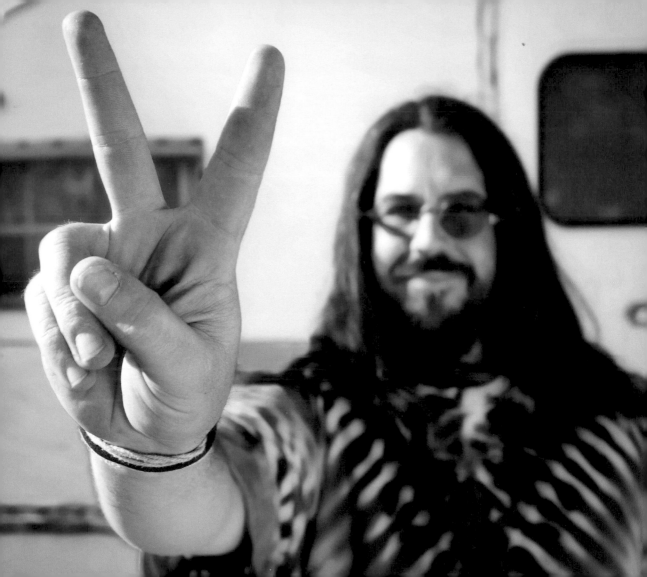

'60s Flashback

Time It Was and What a Time It Was

WILLOW CREEK PRESS®

© 2010 Willow Creek Press

All Rights reserved. No part of this book may be reproduced or transmitted in any form by any means, electronic or mechanical, including photocopying, recording, or by any information storage and retrieval system, without written permission from the Publisher.

Published by Willow Creek Press
P.O. Box 147, Minocqua, Wisconsin 54548

For information on other Willow Creek Press titles,
call 1-800-850-9453

Photos on Pages 8, 10, 13, 14, 17, 22, 25 are believed to be in the public domain.

Photo Credits: p6 © Bettmann/Corbis; p18 © ClassicStock/Masterfile; p21 © ClassicStock/Masterfile; p24 © Darrell Lecorre/Masterfile; p26 © ClassicStock/Masterfile; p28 © Superstock/Masterfile; p33 © ClassicStock/Masterfile; p34 © Sunset Boulevard/Corbis; p36 © Sunset Boulevard/Corbis; p39 © Bettmann/Corbis; p40 © Sunset Boulevard/Corbis; p42 © Bettmann/Corbis; p45 © Bettmann/Corbis; p47 © Sunset Boulevard/Corbis; p48 © Sunset Boulevard/Corbis; p52 © Michael Ochs Archives/Corbis; p55 © Bettmann/Corbis; p57 © Bettmann/Corbis; p58 © Bettmann/Corbis; p60 © Underwood & Underwood/Corbis; p62 © Michael Ochs Archives/Corbis; p74 © ClassicStock/Masterfile; p80 © ClassicStock/Masterfile; p81 © ClassicStock/Masterfile; p83 © ClassicStock/Masterfile; p88 © Transtock/Corbis; p90 © Ron Kimball/Kimballstock.com; p91 © Ron Kimball/Kimballstock.com; p93 © Ron Kimball/Kimballstock.com; p95 © Ron Kimball/Kimballstock.com;

Printed in Canada

CONTENTS

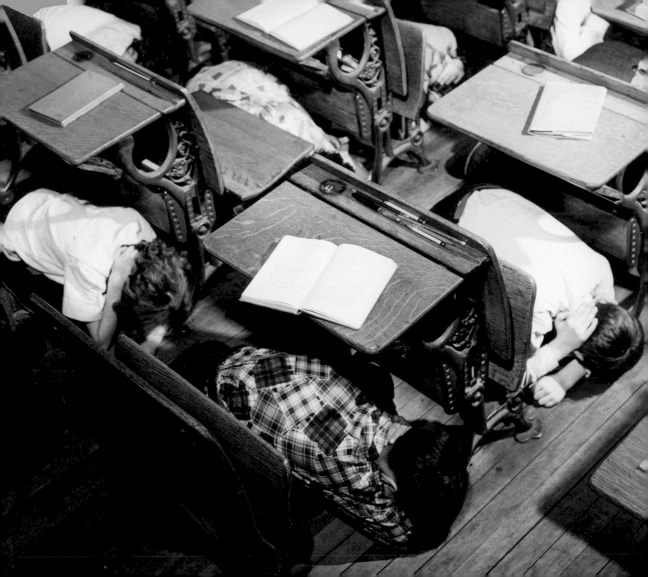

INTRODUCTION

"If you can remember anything about the sixties, you weren't really there"

-Paul Katner

The above quote may apply to full-blown stoners who never really left the sixties, but most of us who were there *do* remember this remarkable time with both bittersweet sadness and profound fondness. We entered the epoch as innocent kids (taught to hide beneath our desks in case of nuclear attack) who took it to the streets as pugnacious teenagers and emerged from the end of this astonishing time tunnel as young adults seasoned in the sadness of war and assassinations; aspiring to ideals of civil rights at home and peace on earth.

We moved on from there to careers, marriages, families, middle age, and grandparenthood. And now those beloved years are but a memory. But what memories they are! We hope you enjoy the ride!

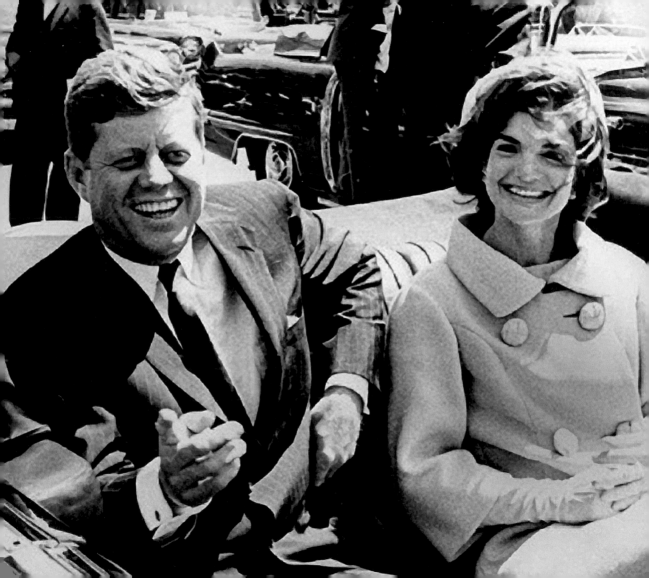

> "We stand today on the edge of a new frontier—the frontier of the 1960's."
>
> -John F. Kennedy, 1961

POWER OF THE PEOPLE

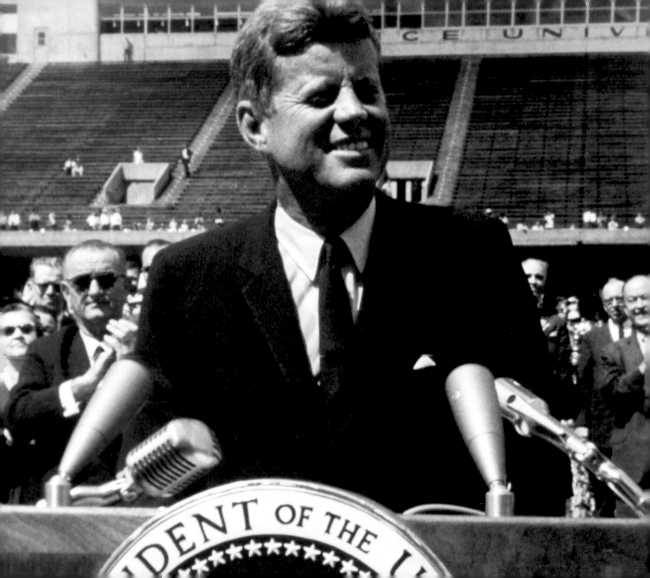

JOHN F. KENNEDY

"Do you realize the responsibility I carry? I'm the only person standing between Richard Nixon and the White House."

"And so, my fellow Americans, ask not what your country can do for you; ask what you can do for your country."

"Forgive your enemies, but never forget their names."

"Efforts and courage are not enough without purpose and direction."

"A man may die, nations may rise and fall, but an idea lives on."

MUHAMMAD ALI

"If they can make penicillin out of moldy bread, they can sure make something out of you."

"It's just a job. Grass grows, birds fly, waves pound the sand. I beat people up."

"A man who views the world the same at fifty as he did at twenty has wasted thirty years of his life."

"I hated every minute of training, but I said, 'Don't quit. Suffer now and live the rest of your life as a champion.'"

"Service to others is the rent you pay for your room on earth."

"It's hard to be humble when you're as great as I am."

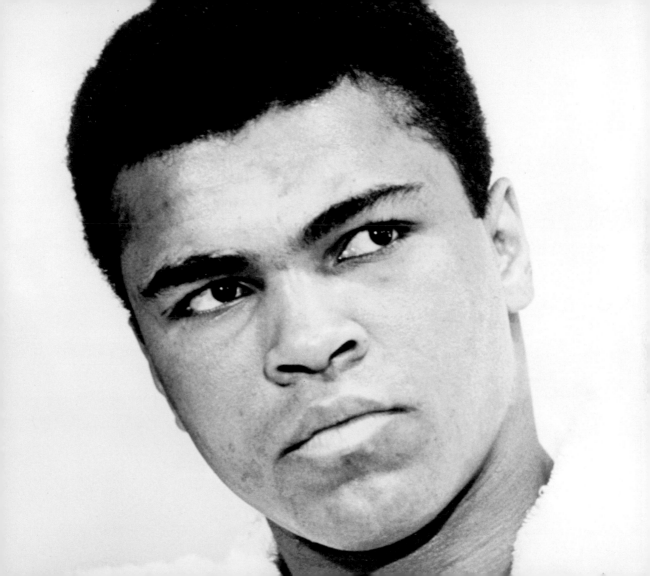

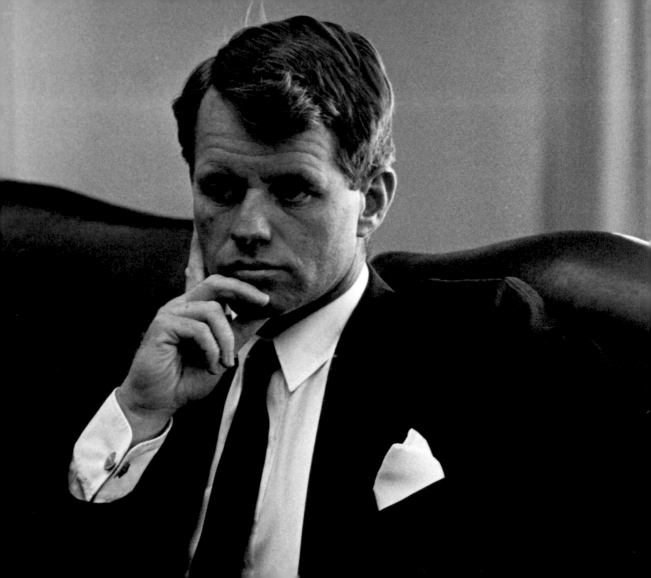

ROBERT F. KENNEDY

"I thought they'd get one of us. But Jack, after all he's been through, never worried about it. I thought it would be me."

"People say I am ruthless. I am not ruthless. And if I find the man who is calling me ruthless, I shall destroy him."

"Only those who dare to fail greatly can ever achieve greatly."

"Tragedy is a tool for the living to gain wisdom, not a guide by which to live."

MARTIN LUTHER KING, JR.

"If physical death is the price I must pay to free my white brothers and sisters from a permanent death of the spirit, then nothing can be more redemptive."

"Darkness cannot drive out darkness; only light can do that. Hate cannot drive out hate; only love can do that."

"At the center of non-violence stands the principle of love."

"A man can't ride your back unless it's bent."

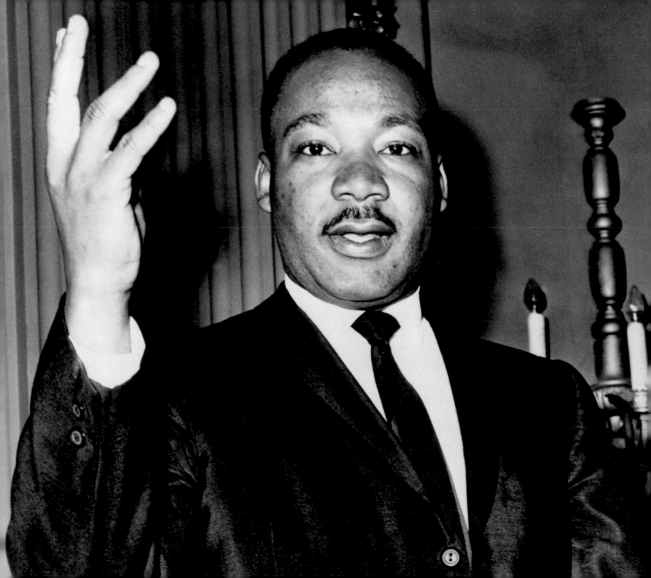

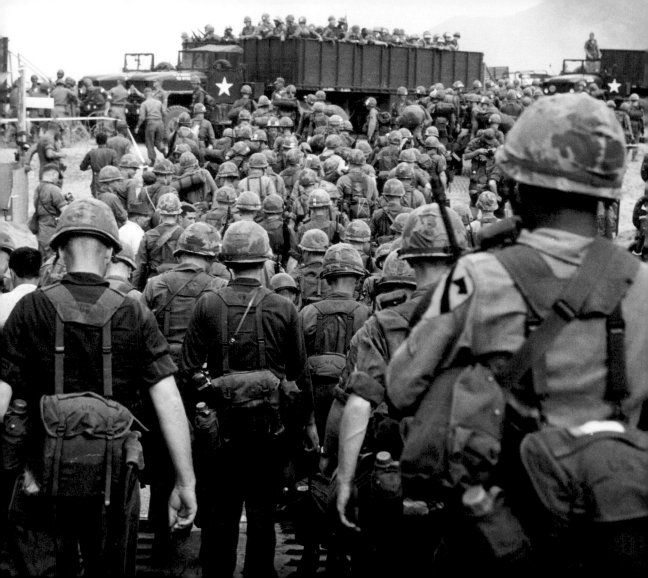

VIETNAM WAR

"Tell the Vietnamese they've got to draw in their horns or we're going to bomb them back into the stone age."

-General Curtis LeMay, 1964

"I'm not going to be the first American president to lose a war."

-Richard M. Nixon, 1969

"I see light at the end of the tunnel."

-Walt W. Rostow, National Security Adviser, 1967

"We should declare war on North Vietnam. We could pave the whole country and put parking strips on it and still be home by Christmas."

-Ronald Reagan, 1965

"No event in American history is more misunderstood than the Vietnam war. It was misreported then, and it is misremembered now."

-Richard M. Nixon

"Within the soul of each Vietnam veteran there is probably something that says, 'Bad war, good soldier'. Only now are Americans beginning to separate the war from the warrior."

-Max Cleland

"Now we have a problem in making our power credible, and Vietnam is the place."

-John F. Kennedy, 1961

"Vietnam was lost in the living rooms of America—not on the battlefields of Vietnam."

-Marshal McLuhan

"The war has already stretched the generation gap so wide that it threatens to pull the country apart."

Senator Frank Church

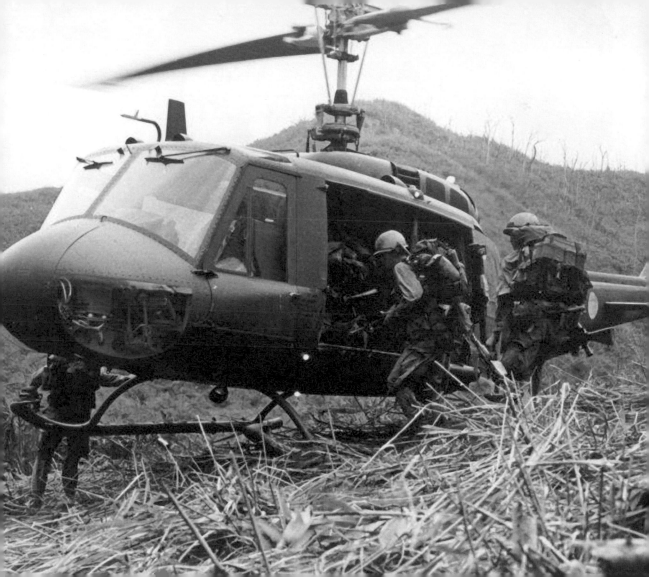

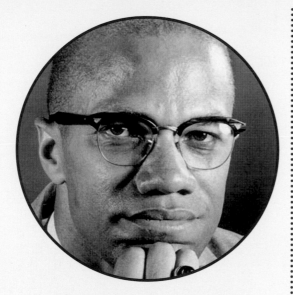

"We have not been told the truth about Oswald."

-Senator Richard Russell,
former Warren Commissioner

"The thing the sixties did was to show us the possibilities and the responsibility that we all had. It wasn't the answer. It just gave us a glimpse of the possibility."

-John Lennon

"I am for violence if non-violence means we continue postponing a solution to the American black man's problem just to avoid violence."

-Malcolm X

"You're either part of the solution or part of the problem."
-Eldridge Cleaver

"Good morning! What we have in mind is breakfast in bed for four hundred thousand."
-Wavy Gravy at Woodstock

"Those times I burned my guitar was like a sacrifice. You sacrifice the things you love. I love my guitar."
-Jimi Hendrix

"The sixties aren't over yet, not until the fat lady gets high!"
-Ken Kesey

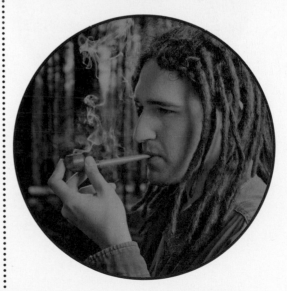

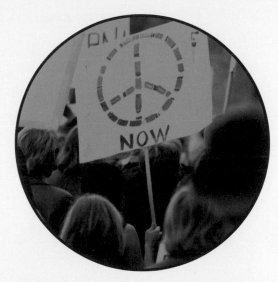

"Make love, not war"
-Peace slogan

"With our love we could save the world."
-George Harrison

"I hate to advocate drugs, alcohol, violence or insanity to anyone, but they've always worked for me."
-Hunter S. Thompson

"Being conscious is cutting through your own melodrama and being right here. Exist in no mind, be empty, here now, and trust that as a situation arises, out of you will come what is necessary to deal with that situation, including the use of your intellect when appropriate."
-Ram Dass

"The real 1960's began on the afternoon of November 22, 1963. It came to seem that Kennedy's murder opened some malign trap door in American culture, and all the wild bats flapped out."

-Lance Morrow

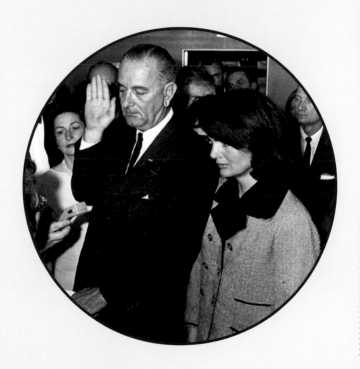

"Drugs are a bet with your mind."

-Jim Morrison

"Of all the things I've lost, I miss my mind the most.

-Jimi Hendrix

"Let me say at the risk of seeming ridiculous that the true revolutionary is guided by great feelings of love."

-Che Guevara

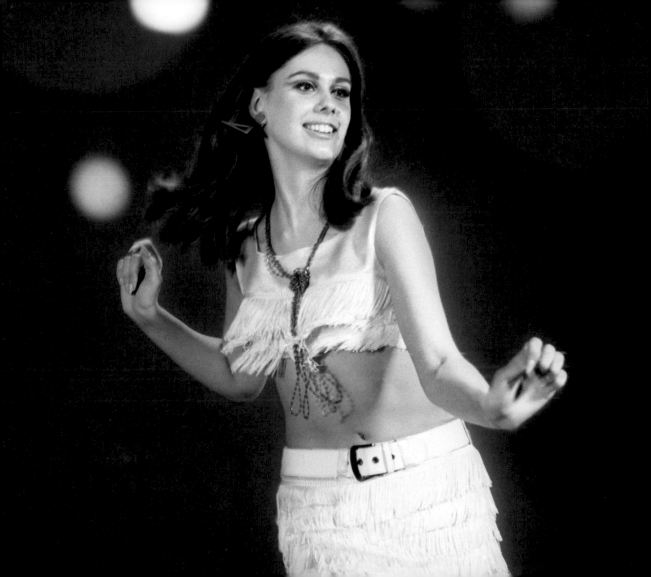

"The fashion of this world passeth away"
—1 Corinthians

FADS, FASHIONS
& FAVORITES

> "Fashion ...produces beautiful things which always become ugly with time."
> —Jean Cocteau

AFROS
AMERICAN BANDSTAND
ANKLE BELLS
ARMY/NAVY
SURPLUS CLOTHING
BELLBOTTOMS
BLACK LIGHTS

CHINESE **FIRE DRILLS**
DRIVE-INS

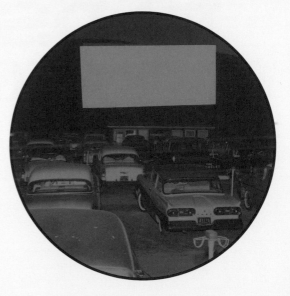

> ## "Every generation laughs at the old fashions, but follow religiously the new"
> —Henry David Thoreau

FALLOUT SHELTERS

FRILLY SHIRTS

FURRY VESTS

GO-GO BOOTS

GRANNY GLASSES

HALTER TOPS

HASH

HEADBANDS

"Fashion is in the sky, in the street, fashion has to do with ideas, the way we live, what is happening."

—Coco Chanel

HIP HUGGERS

HITCHHIKING

IRONED HAIR

LAVA LAMPS

LOVE BEADS

MACRAME

MINI SKIRTS

> "In difficult times fashion is always outrageous."
> —Elsa Shiapparelli

MOOD RINGS
PEACE SIGNS

PEACE SYMBOLS
PEASANT SKIRTS
POP ART
SEA MONKEYS
SLOGAN BUTTONS
SPIDER PLANTS
STROBE LIGHTS
TIE-DYED T-SHIRTS

> "Dance first. Think later.
> It's the natural order."
> - Samuel Beckett

TURTLENECKS

VINYL LPS

VW BUSSES

WIDE BELTS

WOODSTOCK!

THE BOSTON MONKEY

THE CHICKEN

THE DOG

THE FLY

THE FREDDIE

THE FRUG

HITCHHIKE

THE HULLY GULLY

THE JERK

> **"There is a bit of insanity in dancing that does everybody a great deal of good."**
> -Edwin Denby

THE MASHED POTATO

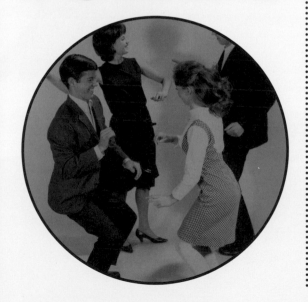

THE MONKEY
THE MONSTER MASH
THE PENGUIN
THE SKA
THE STROLL
WALKING THE DOG

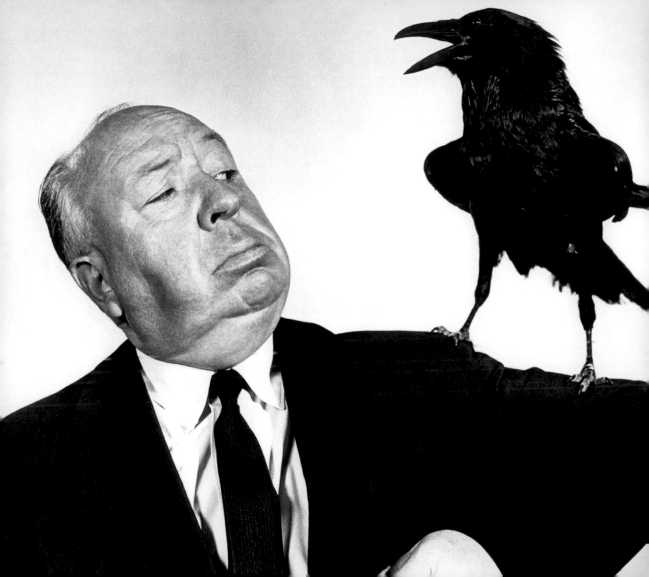

> "For me, the cinema is not a slice
> of life, but a piece of cake."
>
> —Alfred Hitchcock

LET'S ALL GO TO THE MOVIES

The memorable films of the decade started with 1960's "Psycho" which included that classic wet-your-pants shower scene and ended in 1969 with such timeless masterpieces as "Midnight Cowboy". In between were scores of good, bad and ugly movies (including "The Good, the Bad, and the Ugly"). How many of these can you remember?

"Open the pod bay doors, HAL"

-Kear Dullea as Dave Bownman, from 2001: A Space Odyssey, 1968

8 ½ (1963)
13 Ghosts (1960)
101 Dalmatians (1961)
2001: A Space Odyssey (1968)

A

The Absent-Minded Professor (1961)
Advise and Consent (1962)
Alfie (1966)
The Alphabet Murders (1965)
The Agony and the Ecstasy (1965)
Alice's Restaurant (1969)
Alpha Ville (1966)
The Ambushers (1967)
America, America (1963)
Anne of the Thousand Days (1969)
The Apartment (1960)
An Autumn Afternoon (1962)

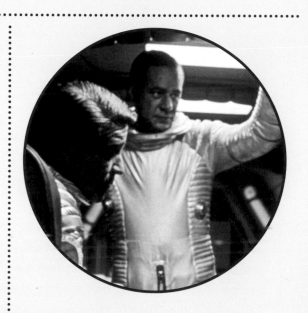

> ## "Kid, the next time I say 'Let's go to someplace like Bolivia', let's go to someplace like Bolivia."
> -Paul Newman as Butch Cassidy, from Butch Cassidy and the Sundance Kid, 1969

B

Babes in Toyland (1961)

Baby the Rain Must Fall (1965)

Ballad of a Bounty Hunter (1968)

Bang Bang Kid (1967)

Banning (1967)

Barbarella (1968)

Battle of the Last Panzer (1969)

Batman (1966)

Beach Blanket Bingo (1965)

The Beast of Yucca Flats (1961)

Becket (1964)

The Bedford Incident (1965)

The Big Gundown (1966)

Big Red (1962)

The Big Shave (1967)

Bikini Beach (1964)

Billy Liar (1963)

The Birds (1963)

Blood and Black Lace (1964)

Blood Bath (1966)

Blowup (1966)

Blue Hawaii (1961)

Blue Movie (1969)

Bob & Carol & Ted & Alice (1969)

Bonnie and Clyde (1967)

> ## "We rob banks."
> -Warren Beatty as Clyde Barrow, from Bonnie and Clyde, 1967

Bon Voyage (1962)

Boot Hill (1969)

Born Free (1966)

A Boy Named Charlie Brown (1969)

The Brain That Wouldn't Die (1962)

Breakfast at Tiffany's (1961)

Butch Cassidy and the Sundance Kid (1969)

Bye Bye Birdie (1963)

> # "What we got here is failure to communicate."
> -Strother Martin as Captain, from Cool Hand Luke, 1967

C

Camelot (1967)

Cape Fear (1962)

Casino Royale (1967)

Cat Ballou (1965)

Changes of Habit (1969)

Chappaqua (1966)

Charade (1963)

Charro! (1969)

Che! (1969)

Chelsea Girls (1969)

Chitty Chitty Bang Bang (1968)

The Christmas Kid (1967)

Clambake (1967)

Cleopatra (1963)

Color Me Blood Red (1965)

Common Law Cabin (1967)

Cool Hand Luke (1967)

Curse of the Fly (1965)

D

Day of Anger (1967)

Days of Wine and Roses (1962)

Death Rides a Horse (1967)

Dementia 13 (1963)

A Devilish Homicide (1965)

The Dirty Dozen (1967)

Django (1966)

Doctor Doolittle (1967)

Doctor Zhivago (1965)

Dr. Goldfoot and the Bikini Machine (1965)

Dr. No (1962)

Dr. Strangelove (1964) (1968)

> # "Gentlemen, you can't fight in here! This is the War Room!"
> -Peter Sellers as President Merkin Muffley, from Dr. Strangelove, 1964

"Bond. James Bond."

Sean Connery as James Bond, from Dr. No, 1962

Dr. Terror's House of Horrors (1965)
Dracula Has Risen from the Grave (1968)
The Drums of Tabu (1966)

E
Easy Come, Easy Go (1967)
Easy Rider (1969)
Elmer Gantry (1960)
The Emerald of Artatama (1969)
Emil and the Detectives (1964)
The Endless Summer (1966)

F
Faces (1968)
Fail-Safe (1964)
Fanny (1961)
The Fearless Vampire Killers (1967)
The Fickle Finger of Fate (1967)
Finders Keepers, Lovers Weepers! (1968)

"They call me *Mister* Tibbs!"

Sidney Poitier as Virgil Tibbs, from In The Heat Of The Night, 1967

Finger on the Trigger (1965)
Finian's Rainbow (1968)
A Fistful of Dollars (1964)
Flaming Creatures (1963)
Flesh (1968)
The Flesh Eaters (1964)
The Flight of the Phoenix (1965)
Follow Me, Boys! (1966)
Follow That Dream (1962)
For a Few Dollars More (1967)
Frankenstein Created Woman (1967)
Frankie and Johnny (1966)
From Russia with Love (1963)
Fun in Acapulco (1963)
Funny Girl (1968)

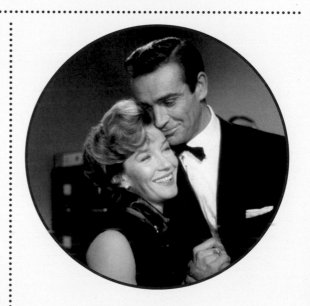

"Hello gorgeous."

-Barbra Streisand as Fanny Brice, from Funny Girl, 1968

> # "Mrs. Robinson, you're trying to seduce me."
> Dustin Hoffman as Ben Braddock, from The Graduate, 1967

G

G.I. Blues (1960)

Girl Happy (1965)

The Girl Who Returned (1969)

Girls! Girls! Girls! (1962)

The Gnome-Mobile (1967)

Gold finger (1964)

> # "A martini. Shaken, not stirred."
> -Sean Connery as James Bond, from Goldfinger, 1964

Good Morning and ... Goodbye! (1967)

The Good, the Bad, and the Ugly (1966)

The Graduate (1967)

The Great Escape (1963)

The Great Silence (1968)

The Great Race (1965)

The Great Silence (1968)

The Green Berets (1968)

The Green Eyed Elephant (1967)

Guess Who's Coming to Dinner (1967)

The Guns of Navarone (1961)

Gypsy (1962)

H

Hallucination (1966)

The Happiest Millionaire (1967)

A Hard Day's Night (1964)

Harum Scarum (1964)

The Haunting (1963)

Head (1968)

Hell is for Heroes (1962)

Hello, Dolly! (1969)

> ## "There's only one kind of peace I know of, Marshal. That's the kind my brother's got."
>
> -Eli Wallach as Charlie Gant, from How the West Was Won, 1962

Help! (1965)
High and Low (1963)
High Time (1960)
The Hill (1965)
The Horror of Party Beach (1964)
Hour of the Wolf (1968)
How the West Was Won (1962)
How to Steal a Million 1966)
Head 1963)
The Hustler (1961)

I

I Am Curious (Yellow) (1967)
I Am Curious (Blue) 1968
I Love You, Alice B. Toklas (1968)
I Passed for White (1960)
The Illustrated Man (1969)
The Incredible Journey (1963)
The Incredible Mr. Limpet (1964)

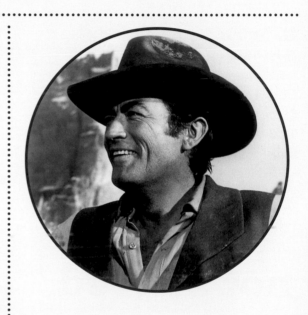

"The best of them won't come for the money. They'll come for me."

Peter O'Toole as Lawrence, from Lawrence of Arabia, 1962

The Innocents (1961)

In Search of the Castaways (1962)

Inside Daisy Clover (1965)

In the Heat of the Night (1967)

The Ipcress File (1965)

It Happened at the World's Fair (1963)

It's a Mad, Mad, Mad, Mad World (1963)

J

Jason and the Argonauts (1963)

Judgement at Nuremberg (1961)

Jules and Jim (1961)

The Jungle Book (1967)

K

Kid Galahad (1962)

Kidnapped (1960)

King of Kings (1961)

Kissin' Cousins (1964)

Kiss Me, Stupid (1964)

The Kanck, and How to Get it (1965)

Knife in the Water (1962)

L

La Dolce Vita (1962)

Lawrence of Arabia (1962)

The Learning Tree (1969)

The Leopard (1963)

Lilies of the Field (1963)

The Lion in Winter (1968)

The Little Shop of Horrors (1960)

Lolita (1962)

The Longest Day (1962)

The Lost World (1960)

The Love Bug (1969)

Love with the Proper Stranger (1963)

> # "I'm walkin here! I'm walkin here!"
> -Dustin Hoffman as 'Ratso' Rizzo, from Midnight Cowboy, 1969

M

Magical Mystery Tour (1967)
The Magic Christian (1969)
The Magnificent Seven (1960)
A Man for All Seasons (1966)
The Man Who Shot Liberty Valance (1962)
The Manchurian Candidate (1962)
Mary Poppins (1964)
McLintock (1963)
Medium Cool (1969)
The Mercenary (1968)
Midnight Cowboy (1969)
The Misadventures of Merlin Jones (1964)
The Misfits (1961)
Mondo Topless (1966)
The Monkey's Uncle (1965)
More (1969)
Morgan! (1966)

Motor psycho (1965)
Murderers Row (1966)
Muscle Beach Party (1964)
The Music Man (1962)
Mutiny on the Bounty (1962)
My Fair Lady (1964)
My Tale is Hot (1964)
Mysterious Island (1961)

> # "Uh, well, sir, I ain't a f'real cowboy. But I am one helluva stud!"
> -Jon Voight as Joe Buck, from Midnight Cowboy, 1969

> ## "Hello, this is a recording, you've dialed the right number, now hang up and don't do it again."
>
> -Frank Sinatra as Danny Ocean, from Ocean's Eleven, 1969

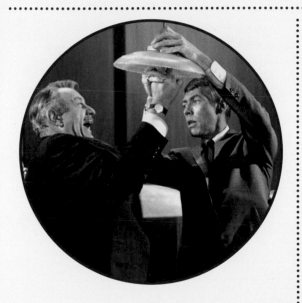

N

Navajo Joe (1966)

Night of the Living Dead (1968)

North to Alaska (1960)

The Nutty Professor (1962)

O

Ocean's Eleven (1960)

The Odd Couple (1968)

OK Connery (1967)

Oliver! (1968)

On Her Majesty's Secret Service (1968)

One Million Years B.C. (1966)

One, Two, Three (1961)

Only Two Can Play (1962)

Orgy of the Dead (1965)

Our Man Flint (1966)

The Outlaws is Coming (1965)

"A boy's best friend is his mother."

-Anthony Perkins as Norman Bates, from Psycho, 1960

P

Pajama Party (1964)
Paradise, Hawaiian Style (1966)
The Parent Trap (1961)
A Passion (1969)
The Pawnbroker (1965)
Peeping Tom (1960)
Penelope (1966)
The Pink Panther (1964)
Pinocchio in Outer Space (1965)
The Pit and the Pendulum (1961)
Planet of the Apes (1968)
Point Blank (1967)
Pollyanna (1960)
The President's Analyst (1967)
Primary (1960)
Promises! Promises! (1963)
Psycho (1960)
Psych-Out (1968)

"Take your stinking paws off me, you damned, dirty ape!"

-Charlton Heston as Taylor, from Planet of the Apes, 1968

R

Rachel, Rachel (1968)
Rascal (1969)
The Rat Race (1960)
The Raven (1963)

"We all go a little mad sometimes."

Anthony Perkins as Norman Bates, from Psycho, 1960

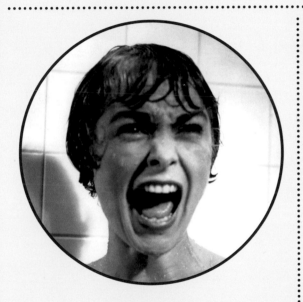

The Red Desert (1964)
Repulsion (1965)
Revolution (1968)
Ride the Whirlwind (1966)
Romeo and Juliet (1968)
Rosemary's Baby (1968)
Roustabout (1964)
The Russians Are Coming, the
Russians are Coming (1968)

"Don't tell them anything! He hasn't even tortured you yet!"

Sheldon Collins as Pete Whittaker, from The Russians
Are Coming the Russians Are Coming, 1966

"I was home. What happened? What the hell happened?"

-Steve McQueen as Jake Holman, from The Sand Pebbles, 1966

S

The Sand Pebbles (1966)

Santa Claus Conquers the Martians (1964)

Satan's Sadists (1969)

Saturday Night and Sunday Morning (1960)

Savage Sam (1963)

Scorpio Rising (1963)

Scream, Baby, Scream (1969)

Seven Days in May (1964)

Shame (1968)

Shark! (1969)

She (1965)

The Shooting (1966)

Ship of Fools (1965)

The Silencers (1966)

Sink the Bismark! (1960)

Skidoo (1968)

Snow White and the Three Stooges (1961)

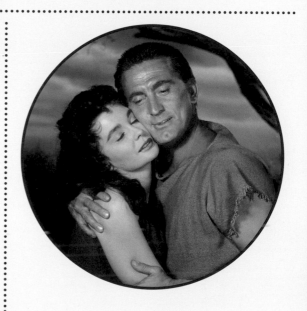

"Rome is the mob."

-John Gavin as Julius Caesar, from Spartacus, 1960

"A good body with a dull brain is as cheap as life itself. "

-Peter Ustinov as Batiatus, from Spartacus, 1960

Sons and Lovers (1960)
The Sound of Music (1965)
Spartacus (1960)
Speedway (1968)
Spinout (1966)
Splendor in the Grass (1961)
The Spy Who Came in from the Cold (1965)
Star! (1968)
Stay away, Joe (1968)

Stereo (1969)
A Study in Terror (1965)
Summer Magic (1963)
The Sundowners (1960)
Sweet Charity (1969)
Swiss Family Robinson (1960)
The Sword in the Stone (1963)

T

Take the Money and Run (1969)
Taste the Blood of Dracula (1969)
That Darfn Cat! (1965)
That Touch of Mink (1962)
The Thomas Crown Affair (1968)
Thoroughly Modern Millie (1967)
Those Magnificent Men in Their Flying Machines (1965)
A Thousand Clowns (1965)
The Three Stooges in Orbit (1962)

> "All of you! You all killed him! And my brother,
> and Riff. Not with bullets, or guns, with hate.
> Well now I can kill, too, because now I have hate!"
>
> -Natalie Wood as Maria, from West Side Story, 1961

The Three Stooges Meet Hercules (1962)

Through a Glass, Darkly (1961)

Thunderball (1965)

Tickle Me (1965)

A Tiger Walks (1964)

The Time Machine (1960)

To Kill a Mockingbird (1962)

Tom Jones (1963)

Torture Garden (1967)

The Train (1964)

The Trial (1962)

The Trip (1967)

The Trouble with Girls (1969)

True Grit (1969)

Tunes of Glory (1960)

Two for the Road (1967)

Two or Three Things I Know About Her (1967)

Two Thousand Maniacs! (1964)

U

The Ugly Dachshund (1966)

Ulysses (1967)

The Unforgiving (1960)

V

The Virgin Spring (1960)

Viva Las Vegas (1964)

Vixen! (1968)

W

Wait Until Dark (1967)

The War Lover (1962)

The Wasp Woman (1960)

The Wedding Party (1969)

West Side Story (1961)

What's New Pussycat? (1965)

Where Eagles Dare (1969)

Who's Afraid of Virginia Woolf? (1966)

> ## "No need to be afraid of him, son. He's all bluff."
> -Gregory Peck as Atticus Finch, from To Kill a Mockingbird, 1962

The Wild Angels (1966)
The Wild Bunch (1969)
Wild in the Country (1961)
Wild in the Streets (1968)
Winter Light (1963)
Woman in the Dunes (1964)
The World of Suzie Wong (1960)
The Wrecking Crew (1969)

X

X: The Man with the X-Ray EYES (1963)

Y

Yellow Submarine (1968)
You Only Live Twice (1967)
You're a Big Boy Now (1966)
Yours, Mine and Ours (1968)

Z

Z (1968)
Zorba the Greek (1964)
Zulu (1964)

> ## "What kinda man are you?"
> -James Anderson as Bob Ewell, from To Kill a Mockingbird, 1962

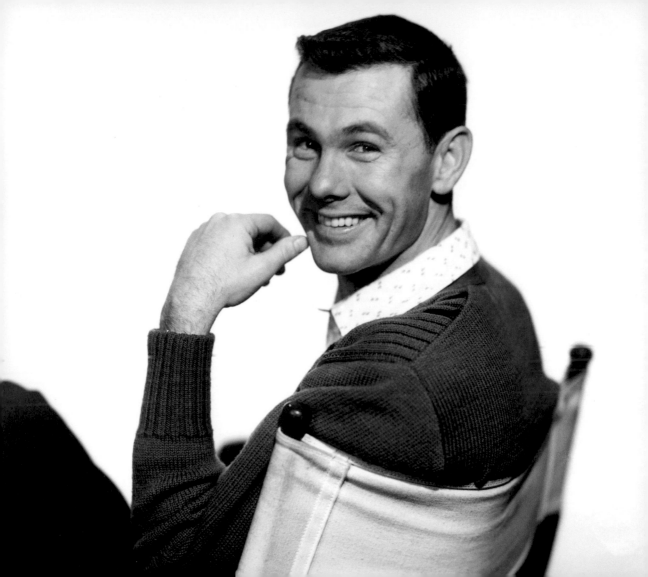

"Color television? Bah, I won't believe it until I see it in black and white."

—Samuel Goldwyn

OUR BELOVED BOOB TUBE

Check out this list of TV shows from the 1960's. If you can remember most of them, your memory bank is hopelessly overloaded with trivia!

> **"Don't you wish there were a knob on the TV to turn up the intelligence? There's one marked 'Brightness', but it doesn't work."**
>
> - Gallagher

12 O'Clock High
60 Minutes
87th Precinct
Adam 12
Addams Family
Andy Griffith Show
Andy Williams Show
The Aquanauts
Arrest And Trial
Assignment Underwater
The Avengers
Baron
Batman
Beautiful Phyllis Diller Show
Ben Casey
Benny Hill Show
The Beverly Hillbillies
Bewitched
The Big Valley

Bing Crosby Show
Blue Angels
The Bold Ones
Bracken's World
The Brady Bunch
Branded
Breaking Point
Bringing Up Buddy
Brothers Brannagan
Burke's Law
Camp Runamuck
Captain Nice
Car 54 Where Are You
Cara Williams
Carol Burnett Show
Channing
Cheaters
Checkmate
Chrysler Theatre

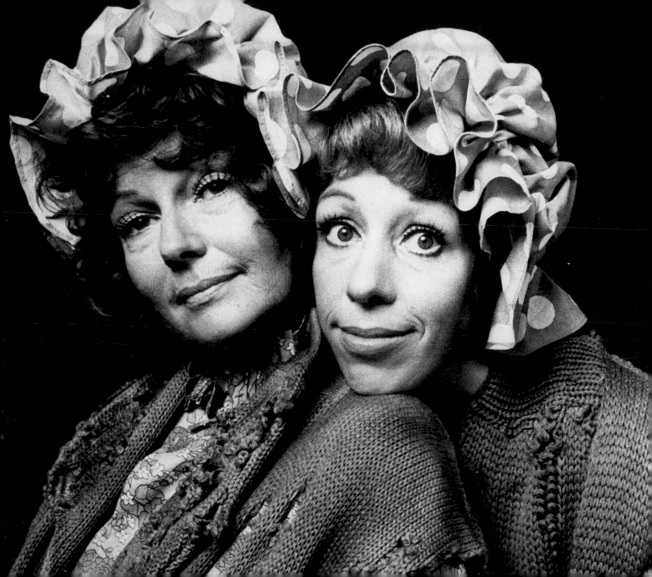

> **"Television is like the invention of indoor plumbing. It didn't change people's habits. It just kept them inside the house."**
>
> -Alfred Hitchcock

Cimarron Strip
Combat
Convoy
Court Martial
Courtship Of Eddie's Father
Daktari
Daniel Boone
Dark Shadows
The Dating Game
The Dean Martin Show
The Defenders
The Dick Van Dyke Show
Doctor Who
Doris Day Show
Double Life Of Henry Phyfe

Ensign O'Toole
Espionage
Everglades
F Troop
The F.B.I.
Family Affair
Farmer's Daughter
Father Of The Bride
The Flintstones
Flipper
The Flying Nun
The Fugitive
Garrison's Gorillas
Gentle Ben
Get Smart
Ghost and Mrs. Muir
Gidget TV Show
Gilligan's Island
Girl From U.N.C.L.E.

> **"Television: A medium—so called because it is neither rare nor well done."**
>
> -Ernie Kovacs

> "It is difficult to produce a television documentary that is both incisive and probing when every twelve minutes one is interrupted by twelve dancing rabbits singing about toilet paper."
>
> -Rod Serling

Gomer Pyle USMC
Green Acres
The Green Hornet
Guestward Ho!
Guns of Will Sonnett
Hawaii Five-0

Hazel
Here Come the Brides
Here's Lucy
High Chaparral
Hogan's Heroes
Honey West
Hong Kong
Hullabaloo
Human Jungle
I Dream of Jeannie
I Spy
Ichabod & Me
I'm Dickens, He's Fenster
The Invaders
Ironside
It Takes A Thief
It's About Time
The Jetsons
Joey Bishop Show

> **"The television is an invention that permits you to be entertained in your living room by people you wouldn't have in your home."**
>
> -David Frost

John Forsythe Show
Johnny Quest
Journey To The Unknown
Judd For The Defense
Judy Garland Show
Land of the Giants
Laredo
The Lawyers
The Lieutenant
The Loner
Lost In Space
Love American Style
Love On A Rooftop
The Lucy Show
Man From U.N.C.L.E.
Man Who Never Was
Mannix
Many Happy Returns
Marcus Welby

Margie
Mayberry R.F.D.
McHale's Navy

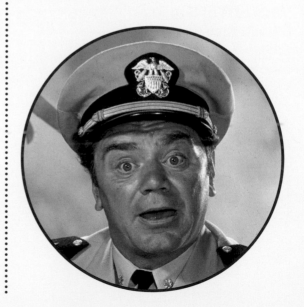

> "If it weren't for Philo T. Farnsworth, inventor of television, we'd still be eating frozen radio dinners."
> -Johnny Carson

McKeever & the Colonel
Medical Center
Mickey
Mission Impossible
Mister Roberts
The Mod Squad
The Monkees
The Monroes (1966)
Mr. Deeds Goes To Town
Mr. Ed
Mr. Novak
Mr. Terrific
Mrs. G. Goes To College
The Munsters
Music Scene
My Living Doll
My Mother the Car
My Sister Eileen
My Three Sons

My World & Welcome To It
Name Of The Game
The New Doctors
The New People
No Time For Sergeants
The Nurses
O.K. Crackerby
Occasional Wife
Our Man Higgins
The Outer Limits
The Outsider
Overland Trail
Patty Duke Show
Pete & Gladys

> "Sex on television can't hurt unless you fall off."
> -Unknown

"I hate television. I hate it as much as peanuts. But I can't stop eating peanuts."

-Orson Welles

Peter Loves Mary
Petticoat Junction
Pistols 'N Petticoats
Please Don't Eat The Daisies
The Prisoner
The Protectors
Pruitts Of South Hampton
Queen & I
Rat Patrol
Redigo
Roaring Twenties
Rocky, Bullwinkle, and Friends
Room 222
Room For One More
Route 66
Rowan/Martin's Laugh-In
Run For Your Life
The Saint
Saints & Sinners

Secret Agent
Shannon
Slattery's People
Smothers Brothers Comedy Hour
Star Trek

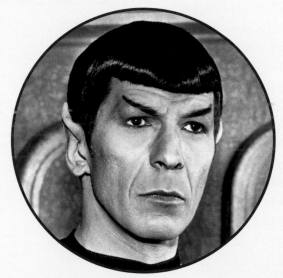

> "I find television to be very educating. Every time somebody turns on the set, I go in the other room and read a book."
>
> -Groucho Marx

Stoney Burke

Surfside 6

Tab Hunter

Tammy

Target: Corruptors

Tarzan (1966)

That Girl

Then Came Bronson

Thriller

Time Tunnel

To Rome With Love

Trails Of O'Brien

The Virginian

Voyage To Bottom Of Sea

Wackiest Ship in the Army

Wendy & Me

Where the Action Is

Whiplash

Wild Wild west

Zero One

> "But it was the dancing—only the dancing that stopped the pain."
>
> -Anthony Quinn as Zorba, from Zorba the Greek, 1964

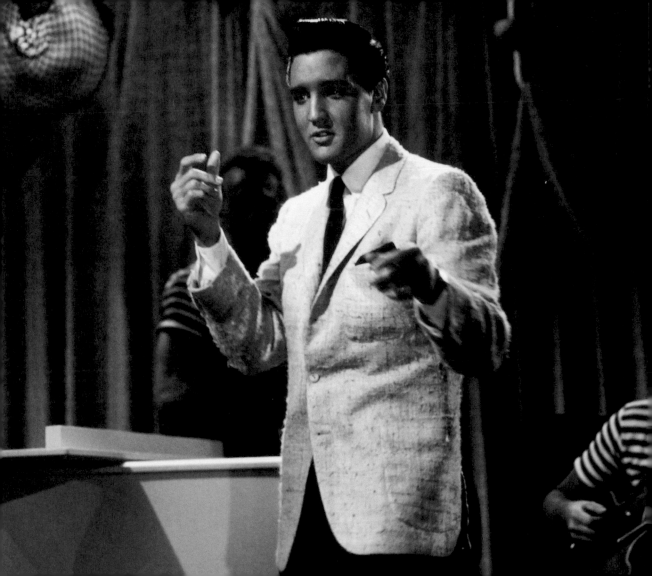

> "I may be old, but I got to see all the great bands."
> —Bumper Sticker

DO YOU BELIEVE IN ROCK & ROLL

The decade began innocently enough with catchy melodies from the usual suspects: Elvis, Frankie Avalon, Ray Charles, et al. But the world of rock and roll as we knew it then was about to change. By 1964 the Beatles had established the U.S. beachhead for what was to become the famous British Invasion. Meanwhile, homegrown breakthrough bands drew free-wheeling musical inspiration from seemingly everywhere including their own American folk and blues roots. Their lyrics reflected myriad aspects of contemporary culture including anger and angst at the war, the spiritual aspects of the emerging drug culture, and the Utopian vision of a loving, peaceful world.

1960 NUMBER ONE HITS

Why (Frankie Avalon)

Running Bear (Johnny Preston)

Teen Angel (Mark Dinning)

The Theme from a Summer Place (Percy Faith)

Stuck On You (Elvis Presley)

Cathy's Clown (The Everly Brothers)

Everybody's Somebody's Fool (Connie Francis)

Alley-Oop (Hollywood Argyles)

I'm Sorry (Brenda Lee)

Itsy Bitsy Teenie Weenie Yellow Polka Dot Bikini (Brian Hyland)

It's Now or Never (Elvis Presley)

The Twist (Chubby Checker)

My Heart Has a Mind of its Own (Connie Francis)

Save the Last Dance for Me (The Drifters)

I Want to be Wanted (Brenda Lee)

Georgia on my Mind (Ray Charles)

Stay (Maurice Williams & The Zodiacs)

Are You Lonesome Tonight? (Elvis Presley)

Runnin' Bear dove
in the water
Little White Dove
did the same
And they swam
out to each other
Through the swirling
stream they came

-Running Bear by Johnny Preston, 1960

1961 NUMBER ONE HITS

Are You Lonesome Tonight? (Elvis Presley)

Wonderland (Night Bert Kaempfert)

Will You Love Me Tomorrow? (The Shirelles)

Calcutta (Lawrence Welk)

Pony Time (Chubby Checker)

Surrender (Elvis Presley)

Bluc Moon (The Marcels)

Runaway - (Del Shannon)

Mother-In-Law (Ernie K-Doe)

Travelin' Man (Ricky Nelson)

Running Scared (Roy Orbison)

Moody River (Pat Boone)

Quarter to Three (Gary and the U.S. Bonds)

August Tossin' and Turnin' (Bobby Lewis)

Michael (The Highwaymen)

Take Good Care of my baby (Bobby Vee)

Hit the Road Jack (Ray Charles)

Runaround Sue (Dion)

Bib Bad John (Jimmy Dean)

Please Mr. Postman (The Marvelettes)

The Lion Sleeps Tonight (The Tokens)

I'm a-walking in the rain
Tears are falling and I feel the pain
Wishing you were here by me
To end this misery and I wonder
I wah, wah, wah, wah wonder
Why; Why, why, why, why, why she ran away
And I wonder when she will stay
My little runaway a-run, run, run, run, a-runaway

Runaway by Del Shannon, 1961

1962 NUMBER ONE HITS

The Lion Sleeps Tonight - The Tokens
The Twist - Chubby Checker
Peppermint Twist - Part I - Joey Dee & The Starliters
Duke of Earl - Gene Chandler
Hey! Baby - Bruce Chanel
Don't Break the Heart That Loves You - Connie Francis
Johnny Angel - Shelley Fabares
Good Luck Charm - Elvis Presley
Soldier Boy - The Shirelles
Stranger on the Shore - Mr. Acker Bilk
I Can't Stop Loving You - Ray Charles
The Stripper - David Rose
Roses are Red My Love - Bobby Vinton
Breaking Up is Hard to Do - Neil Sedaka
The Loco-Motion - Little Eva
Sheila - Tommy Roe
Sherry - The Four Seasons
Monster Mash - Bobby Boris & the Crypt Pickers
He's a Rebel - The Crystals
Big Girls Don't Cry - The Four Seasons
Telstar - The Tornadoes

1963 NUMBER ONE HITS

Telstar (The Tornadoes)
Go Away Little Girl (Steve Lawrence)
Walk Right In (The Rooftop Singers)
Hey Paul (Paul & Paula)
Walk Like a Man (The Four Seasons)
Our Day Will Come (Ruby & The Romantics)
He's so Fine (The Chiffons)
I Will Follow Him (Little Peggy March)
If You Wanna be Happy (Jimmy Soul)
Sukiyaki (Kyu Sakamoto)
Easier Said Than Done (The Essex)
Surf City (Jan & Dean)
So Much in Love (The Tymes)
Fingertips, Part II (Little Stevie Wonder)
My Boyfriend's Back (The Angels)
Blue Velvet (Bobby Vinton)
Sugar Shack (Jimmy Gilmer & The Fireballs)
Deep Purple (Neeno Temple & April Stevens)
I'm Leaving it Up to You (Dale & Grace)
Dominique (The Singing Nun)

**The wayward wind
is a restless wind
A restless wind that
yearns to wander
And I was born the
next of kin
The next of kin to
the wayward wind**

Wayward Wind by Frank Ifield, 1963

1964 NUMBER ONE HITS

There! I've Said it Again (Bobby Vinton)

I Want to Hold Your Hand (The Beatles)

She Loves You (The Beatles)

Can't Buy Me Love (The Beatles)

Hello, Dolly! (Louis Armstrong)

My Guy (Mary Wells)

Love Me Do (The Beatles)

Chapel of Love (The Dixie Cups)

I Get Around (The Beach Boys)

Rag Doll (The Four Seasons)

A Hard Day's Night (The Beatles)

Everybody Loves Somebody (Dean Martin)

The House of the Rising Sun (The Animals)

I Feel Fine (The Beatles)

Come See About Me (The Supremes)

Downtown (Petula Clark)

You've Lost That Lovin' Feelin' (The Righteous Brothers)

This Diamond Ring (Gary Lewis & The Playboys)

My Girl (The Temptations)

Eight Days a Week (The Beatles)

Girl, you really got me goin'
You got me so I don't know what I'm doin'
Yeah, you really got me now
You got me so I can't sleep at night

You Really Got Me by the Kinks, 1964

1965 NUMBER ONE HITS

Stop! In the Name of Love (The Supremes)

I'm Telling You Now (Freddie & The Dreamers)

Game of Love (Wayne Fontana and The Mindbenders)

Mrs. Brown You've Got a Lovely Daughter (Herman's Hermits)

Ticket to Ride (The Beatles)

Help Me Rhonda (The Beach Boys)

Back in My Arms Again (The Supremes)

I Can't Help Myself Sugar Pie Honey Bunch (The Four Tops)

Mr. Tambourine Man (The Byrds)

I Can't Get no Satisfaction (The Rolling Stones)

I'm Henry VIII I am (Herman's Hermits)

I Goy You Babe (Sonny & Cher)

Help! (The Beatles)

Eve of Destruction (Barry McGuire)

Hang on Sloopy (The McCoys)

Yesterday (The Beatles)

Get Off My Cloud (The Rolling Stones)

I Hear a Symphony (The Supremes)

Turn! Turn! Turn! (The Byrds)

Over and Over (The Dave Clark 5)

1966 NUMBER ONE HITS

The Sound of Silence (Simon & Garfunkel)

We Can Work it Out (The Beatles)

My Love (Petula Clark)

Lightnin' Strikes (Lou Christie)

These Boots are Made for Walkin'
(Nancy Sinatra)

You're My Soul and Inspiration
(The Righteous Brothers)

Good Lovin' (The Young Rascals)

Monday, Monday (The Mammas & the Pappas)

When a Man Loves a Woman (Percy
Sledge)

Paint it Black (The Rolling Stones)

Paperback Writer (The Beatles)

Strangers in the Night (Frank Sinatra)

Hanky Panky (Tommy James)

Wild Thing (The Troggs)

Summer in the City (The Lovin' Spoonful)

Sunshine Superman (Donovan)

You Can't Hurry Love (The Supremes)

Cherish (The Association)

Reach Out I'll be There (The Four Tops)

**You don't have to say
you love me
Just be close at hand
You don't have to
stay forever
I will understand
Believe me, believe me
I can't help but love you
But believe me
I'll never let you down**

You Don't Have to Say you Love me
by Dusty Springfield, 1966

1967 NUMBER ONE HITS

I'm a Believer (The Monkees)

Kind of a Drag (The Buckinghams)

Ruby Tuesday (The Rolling Stones)

Love is Here and Now You're Gone
(The Supremes)

Penny Lane (The Beatles)

Happy Together (The Turtles)

Somethin' Stupid' (Frank and Nancy Sinatra)

The Happening (The Supremes)

Grooving' (The Young Rascals)

Respect (Aretha Franklin)

Windy (The Association)

Light My Fire (The Doors)

All You Need is Love (The Beatles)

Ode to Billy Joe (Bobbie Gentry)

The Letter (Box Tops)

To Sir with Love (Lulu)

Incense and Peppermints (Strawberry
Alarm Clock)

Daydream Believer (The Monkees)

Hello Goodbye (The Beatles)

She said there is no reason
And the truth is plain to see
But I wandered through my
playing cards
And would not let her be
One of sixteen vestal virgins
Who were leaving for the coast
And although my eyes were open
They might have just as well've
been closed

A Whiter Shade of Pale by Procol Harum, 1967

1968 NUMBER ONE HITS

Hello Goodbye (The Beatles)

Judy in Disguise (John Fred & His Playboy Band)

Green Tambourine (The Lemon Pipers)

Love is Blue (Paul Mauriat)

The Dock of the Bay (Otis Redding)

Honey (Bobby Goldsboro)

Tighten Up (Archie Bell & The Drells)

Mrs. Robinson (Simon & Garfunkel)

This Guy's in Love With You (Herb Alpert)

Grazing in the Grass (Hugh Maskela)

Hello, I Love You (The Doors)

People Got to Be Free (The Rascals)

Harper Valley P.T.A. (Jeannie C. Riley)

Hey Jude (The Beatles)

Love Child (Diana Ross & The Supremes)

I Heard it Through the Grapevine (Marvin Gaye)

I was drowned, I was washed up and left for dead
I fell down to my feet and I saw they bled, yeah, yeah,
I frowned at the crumbs of a crust of bread, yeah, yeah, yeah
I was crowned with a spike right through my head
But it's all right
In fact it's a gas
But it's all right
I'm Jumpin' Jack Flash, it's a gas, gas, gas

Jumpin' Jack Flash by the Rolling Stones, 1968

1969 NUMBER ONE HITS

I Heard it Through the Grapevine (Marvin Gaye)

Crimson and Clover (Tommy James & The Shondells)

Everyday People (Sly & The Family Stone)

Dizzy (Tommy Roe)

Aquarius (The 5th Dimension)

Get Back (The Beatles)

Love Theme from Romeo & Juliet (Henry Mancini)

In the Year 2525 (Zager & Evans)

Honky Tonk Woman (The Rolling Stones)

Sugar, Sugar (The Archies)

I Can't Get Next to You (The Temptations)

Suspicious Minds (Elvis Presley)

Wedding Bell Blues (The 5th Dimension)

Come Together (The Beatles)

Na Na Hey Hey, Kiss Him Goodbye (Steam)

Leaving on a Jet Plane (Peter, Paul & Mary)

Someday We'll be Together (Diana Ross & The Supremes)

Hope you got your
things together
Hope you are quite
prepared to die
Looks like we're in for
nasty weather
One eye is taken for an eye

Bad Moon Rising by Creedence
Clearwater Revivial, 1969

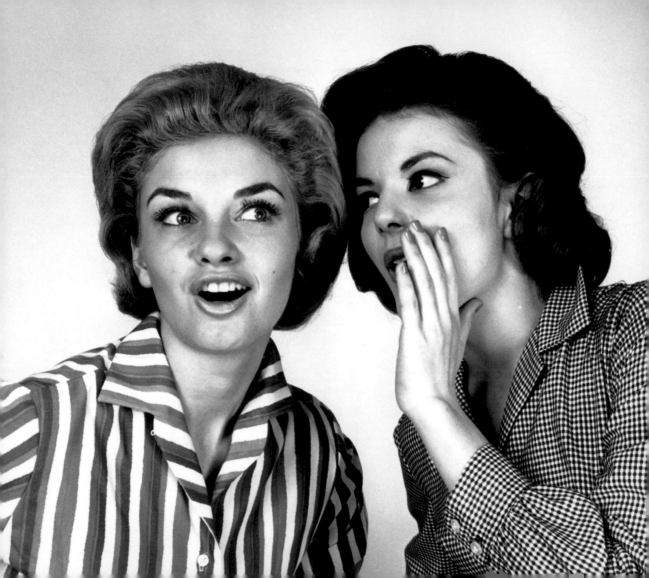

"Hey bro, can you dig the far
out way we used to rap?"

SIXTIES
LINGO

APE
To go nuts

B.A.
Initials for "bare ass"

BAD
Actually it means "very good" or "really cool"

BADASS
A tough guy or something that's really cool - cooler than "bad"

BAG
To steal or illegally acquire. Also relating to a personal issue, as in "What's your bag, man?"

BARF
To vomit. Also see "Ralph"

BIRD, THE
The middle finger raised in a sign of anger or defiance

BITCHIN
Bad, as in "very good" or "really cool"

BLAST
Having a good time

BLITZED
Drunk

BOGART
To hog something, like a cigarette or joint

BOOGIE
To depart quickly, as in "Seeya, I gotta boogie"

BOOK

To depart, as in "Seeya, I'm gonna book"

BOOKIN

To enjoy yourself or to move fast

BOSS

Very cool, as in "bad" or "bitchin"

BREAD

Cash money

BROKE ASS

To work diligently, as in "I really broke ass to pass English class"

BREW

Beer or malt liquor

BRO

Brother, friend or comrade

BRODY

To skid a car in a circle or half-circle, as in "Pull a brody"

BUG

Annoy or bother

BUMMER

Depressed; depression

CANDYASS

Immature, afraid and/or uncool

CAT

A guy

CHERRY

In perfect condition

CHICK

A girl

CHILL

To relax

CHILLIN

The act of relaxing. Also see "Chill"

CHURCH KEY

A portable, handheld can opener

COOL

Awesome

COPASETIC

The state of being contented and trouble-free

CRASH

Fall asleep

CRUISING

Driving up and down the streets at night looking for fun, looking for girls, and desperately hoping to be looked at

DADDY'S CAR

An automobile that's either too cool or too expensive to be owned by the nerd driving it

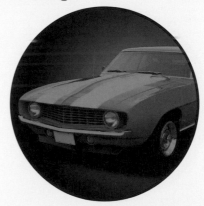

DIG

To comprehend or appreciate something

DIP SHIT

A hopelessly nerdy person

DIP STICK

A nerd, wimp or dweeb

DITZ OR DITZY

An easily confused person or a stupid situation

DOOBIE

A marijuana cigarette; also see "Joint"

DORK

A dip stick, dweeb, wimp or nerd

DRAG

A boring situation, as in "This party's a drag"

DWEEB

A dip stick, nerd or wimp

EASY

Goodbye, as in "Seeya"

FAG

A cigarette; a homosexual

FAR OUT

Way cool. Also a psychedelic reference

FINK

A stool pigeon or tattle tale

FLAKE

See "Dip Shit", "Dipstick", "Dork" and "Dweeb"

FLAKE OFF

A rude way of telling someone to depart or leave you alone

FOX

A gorgeous girl

FREAK OUT

To become startled, disoriented or confused

FREAKY

Something odd, disorienting or confusing

FUNKY

Extremely cool; odd and/or distasteful as in, "This burger tastes funky"

FUZZ

The police. Also see "Heat"

GAS

Fun, as in "We had a gas at the party"

GREASER

A male with slicked back hair

GROOVY

Very cool. Also see "Copasetic"

GROADY

Short for "grotesque"

HACKED

Irate, as in "I'm really hacked at you for doing that"

HACKED OFF

See "Hacked"

HAIRY

A frightening situation

HANG A B.A.

To drop ones pants, bend over and display a "Bare Ass"

HANGING LOOSE

The act of relaxing. Also see "Copasetic"

HAUL ASS

To move quickly; to accelerate, as while driving an automobile; to depart, as in "I'm gonna haul ass. I'll see you tomorrow"

HEAT

The police. Also see "Fuzz" and "Pig"

HEAVY

Profound; sad; very cool

HEP

Cool; in general agreement with or understanding of a situation, as in "I'm hep to that, man"

HIP

See "Hep"

HIT

A single inhalation of a marijuana cigarette, as in "Hey, gimme a hit off that joint". Also see "Toke"

JAZZED

Eager anticipation; a sense of excitement, as in "Hey, I'm really jazzed about the party this weekend"

JAZZED UP

See "Jazzed"

JOINT

A marijuana cigarette; also see "Doobie"

KIBOSH

To deny; to bring to a sudden end or conclusion, as in "My parents put the kibosh on my plans this weekend"

KISS UP

To overtly seek the favor of someone

KNOCKED UP

Pregnant. Also see "PG"

LATER

Goodbye, as in "Seeya". Also see "Easy"

LAY IT ON ME

A phrase used to alert others to the fact that you are prepared to listen to them speak

LOADED

Drunk; intoxicated

MAKE OUT

The act of a guy and girl kissing and petting

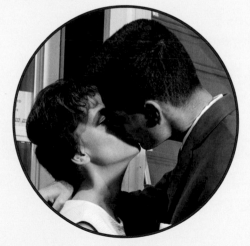

MOON

See "Hang a B.A." and "Pressed Ham"

OLD LADY

Ones mother

OLD MAN

Ones father

ON THE MAKE

Searching for a sexual relationship

OUTTA SIGHT

Very cool; awesome; fantastic; see also "Far Out"

PAD

Living quarters

PADIDDLE

An automobile with but one working headlight

PADUNKLE

An automobile with but one working taillight

PASSION PIT

A drive-in theater

PG

Pregnant; also see "Knocked Up"

PIGS

The police; also see "Heat" and "Fuzz"

PIG OUT

To eat to excess

PRESSED HAM

The visual effect achieved after dropping ones pants in the interior of an automobile and pressing bare buttocks against the passenger window or, if anatomically possible, the rear window. Also see "Hangin a B.A." and "Moon"

PRIMO

Excellent

RAP

To speak or converse

RALPH

To vomit. Also see "Barf"

RIGHT ON

An expression of agreement

RIGHTEOUS

Very cool; exceptionally fine

RIP OFF

The act of stealing

SCARF

To ingest food quickly

SCORE

A term used by a male to describe that he has had or would like to have sexual intercourse with a specific girl, as in "I heard that Mark scored with Jenny last Friday night"; also, to obtain illegal drugs, as in "I heard that Mark scored some weed from Jenny last Friday night"

SCRATCH

Money; also see "Bread"

SCREWED

A state of misfortune, as in "I heard Mark got screwed by Jenny on that pot deal last Friday night" ; also, a term denoting the act of sexual intercourse.

SHAG ASS

To depart abruptly; also see "Haul Ass"

SHOTGUN

The front passenger seat of an automobile

SKAG

An unusually unattractive girl

SKANKY

Disgusting; also see "Groady"

SPAZZIE

To behave in a fashion as to appear to be retarded or a spastic

SPEED FREAK

A habitual user of amphetamines

SQUARE

An "uncool" person

STOKED

Excited; a heightened sense of anticipation; also see "Jazzed"

STONED

A sense of euphoria or innebreation resulting from the ingestion of drugs and/or alcoholic beverages

STONER

A habitual marijuana smoker

SUCK UP

To overtly seeks the favor of someone. Also see "Kiss Up"

SWEAT HOG

A corpulent version of a "Skank"

THREADS

Clothing

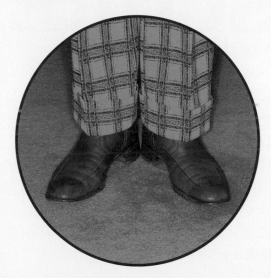

TOKE

A single inhalation of a marijuana cigarette; also see "Hit"

TOOL

A foolish person; also used to describe the act of driving leisurely

TRIPPIN

A hallucinatory experience often induced by the ingestion of LSD

TRIPPY

Weird; profound

TRUCKIN

Traveling from point A to point B

WEDGIE

The result achieved after a victims underwear has been abruptly yanked from behind

WET WILLIE

The result achieved after abruptly inserting a wet finger into a victims ear

WIPE OUT

To fall off a surfboard; to destroy an automobile via a driving accident; to fall; to denote weariness

WOODY

A wood paneled truck or station wagon; an erection

ZITS

Pimples or acne

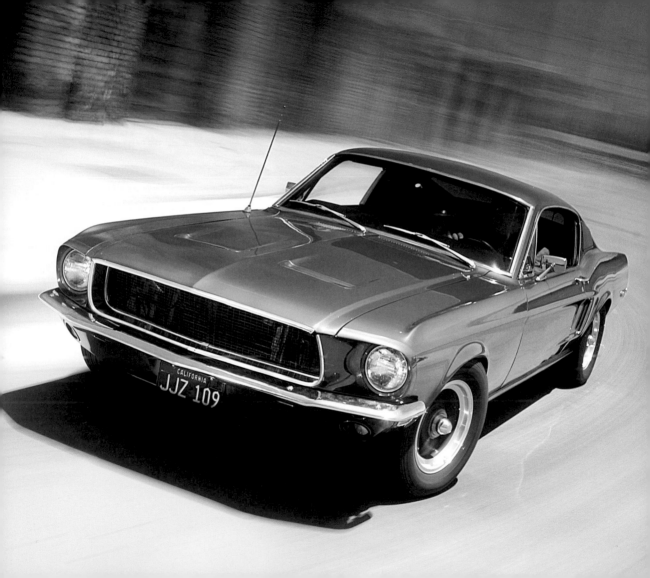

Do not turn on air conditioner at speeds exceeding 120 miles per hour

MUSCLE
CARS

You didn't only see and hear a sixties era muscle car coming, you felt it from your toes to your chest as a roaring V8 with up to 450 of haul-ass-fast-horsepower vibrated through you. They were cool, fast, thrilling, moderately priced, all-American automobiles. Anyone who ever owned one (or even rode shotgun for that matter) never forgets it. But there has always been some question as to what constituted a muscle car as opposed to merely a fast luxury car. Leave it to the Muscle Car Club to clear up matters via their specific interpretation:

TRUE MUSCLE CARS

AMC AMX

BUICK GS

CHEVROLET CAMARO
(SS and Z28 models only)

CHEVROLET CHEVELLE SS

CHEVROLET IMPALA SS

CHEVROLET NOVA
(SS model only)

DODGE CHALLENGER

DODGE CHARGER
(R/T edition)

DODGE CORONET
(R/T edition)

DODGE DART
(require 383 or 440 engines to qualify)

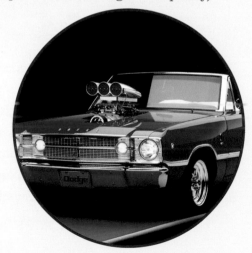

TRUE MUSCLE CARS

DODGE DAYTONA

DODGE SUPER BEE

FORD FAIRLANE/TORINO
(GT and Cobra models only)

FORD GALAXIE
(390 engines required)

FORD MUSTANG
(GTs, Mach 1 and Boss only)

MERCURY COMET/CYCLONE
(GTs, Eliminators and Boss engine models only)

MERCURY COUGAR
(GTs, Eliminators and Boss engine models only)

OLDSMOBILE 442

PLYMOUTH 'CUDA

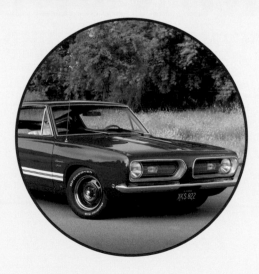

TRUE MUSCLE CARS

PLYMOUTH DUSTER
(340's only)

PLYMOUTH GTX

PLYMOUTH ROAD RUNNER

PLYMOUTH SUPERBIRD

PONTIAC CATALINA 2+2
(400+ cid engines only)

PONTIAC FIREBIRD
(400+ cid engines only)

PONTIAC GTO

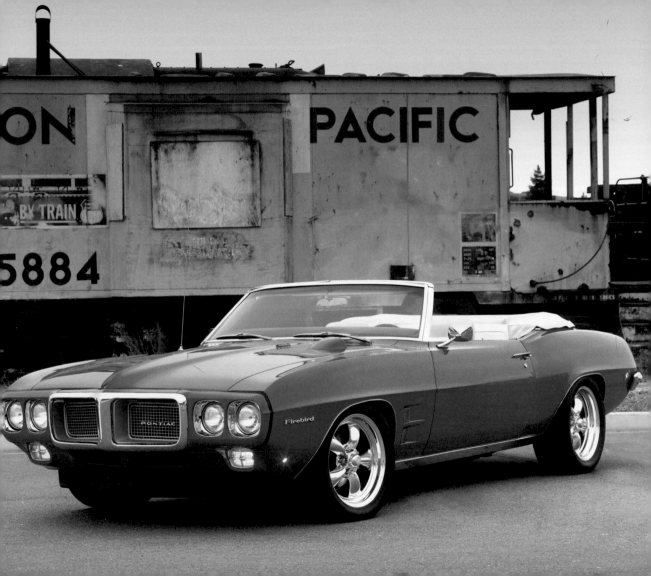

SORRY CHARLIE, NOT QUITE A MUSCLE CAR

BUICK RIVIERA

BUICK SKYLARK
(non-GS)

BUICK WILDCAT

CHEVROLET CORVETTE
(sports car)

CHEVROLET MONTE CARLO

CHRYSLER 300

OLDSMOBILE CUTLASS

PLYMOUTH BARRACUDA
(only 'Cuda models qualify)

PONTIAC GRAND PRIX

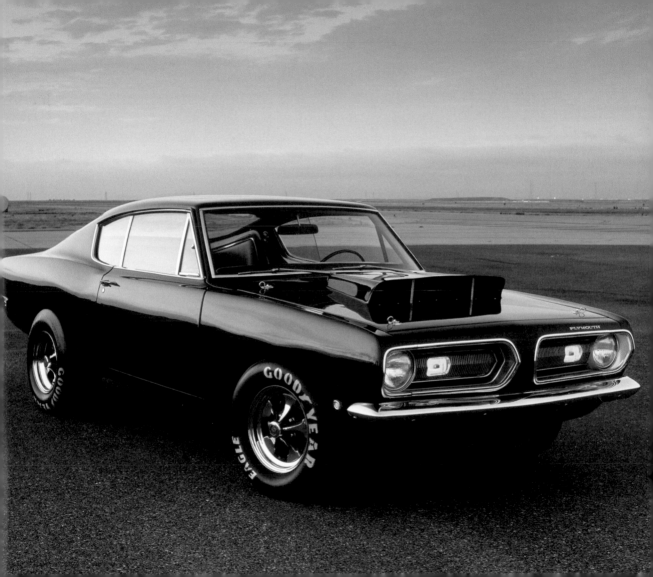